Buildings in Watercolour

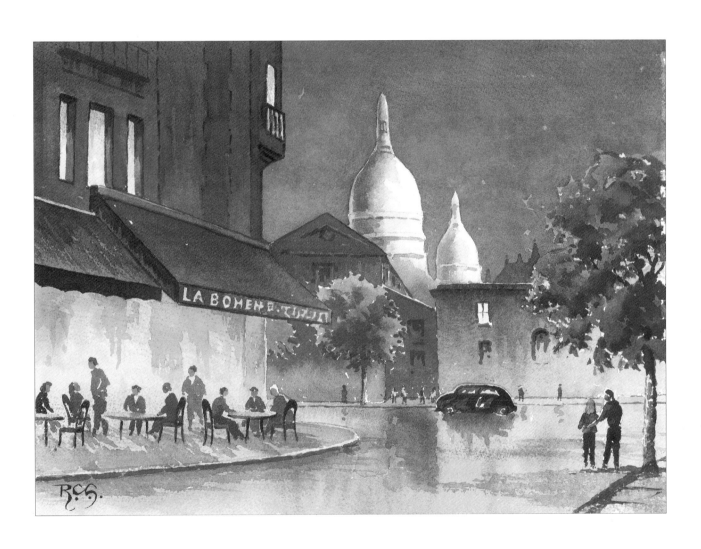

*To my family, my friends, fellow painters and
all those who share my love of pure watercolour*

RCS.

Buildings in Watercolour

RAY CAMPBELL SMITH

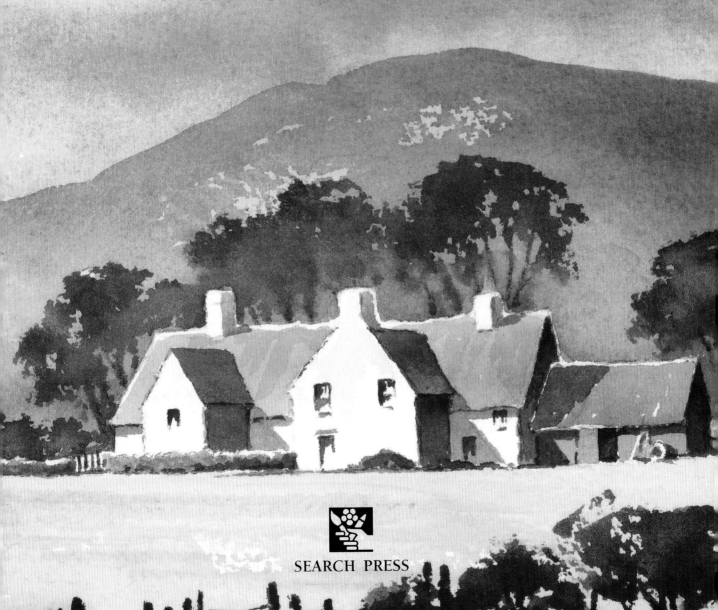

SEARCH PRESS

First published in Great Britain 2004

Search Press Limited
Wellwood, North Farm Road, Tunbridge Wells, Kent TN2 3DR

Reprinted 2006 (twice), 2008

Text copyright © Ray Campbell Smith 2004

Photographs by Roddy Paine Photographic Studios
Photographs and design copyright © Search Press Ltd. 2004

ISBN: 978 1 84448 000 5

The publishers and author can accept no responsibility for any consequences arising from the information, advice or instructions given in this publication.

The publishers would like to thank Winsor & Newton for supplying many of the materials used in this book.

Suppliers
If you have difficulty in obtaining any of the materials and equipment mentioned in this book, then please visit the Search Press website for details of suppliers: www.searchpress.com

Alternatively, you can write to the Publishers at the address above, for a current list of stockists, including firms who operate a mail-order service, or you can write to Winsor & Newton requesting a list of distributers.

Winsor & Newton, UK Marketing
Whitefriars Avenue, Harrow,
Middlesex, HA3 5RH

Publisher's note

All the step-by-step photographs in this book feature the author, Ray Campbell Smith, demonstrating how to paint buildings in watercolour. No models have been used.

Printed in Malaysia

I should like to acknowledge the invaluable professional help I have received from Roz Dace, Editorial Director, and Alison Howard, Editor. I also wish to thank Susannah Baker for converting my scrawl into perfect typescript and, as ever, my wife Eileen for her unfailing encouragement and support.

Cover

Six Bells Lane, Sevenoaks
250 x 310mm (10 x 12in)
Houses built on a slope and seen from a low viewpoint may look attractive but can sometimes cause perspective problems. When in doubt, apply the time-honoured geometric constructions to check your drawing (see page 18). Bear in mind that the lines of old buildings may be a little wayward.

Page 1

Montmartre by Night
280 x 380mm (11 x 15in)
The warm light from the roadside café contrasts with the cool colours of the night sky.

Pages 2–3

Break in the Clouds, Cumbria
280 x 380mm (11 x 15in)
The feeling of light is emphasised by the strong use of tone. The shadowed surroundings make the whitewashed farmhouse and the sunlit field positively shine by contrast. The beams of light direct the eye to the focal point, the farmhouse.

Page 5

Canal Scene, Venice
280 x 380mm (11 x 15in)
The sunlit house on the right is balanced by the shadowed building on the left. The focal point, the white church tower, is comfortably off-centre and the young man is walking into the painting rather than out of it.

Pages 6–7

Cotswold Church
280 x 380mm (11 x 15in)
The autumnal colours in this scene are muted, but the treatment of light adds a sparkle. The sun illuminates the right facing elevations of the buildings and catches some of the trees and the tops of the stone walls. A broken wash suggests tussocky foreground grass.

Contents

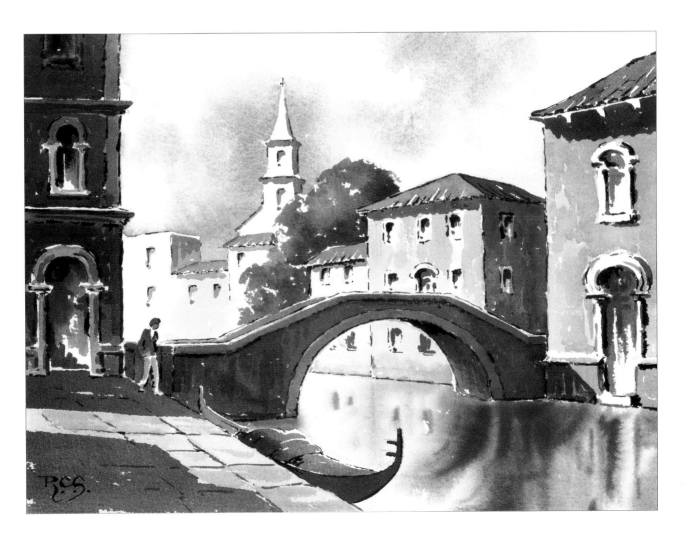

Introduction

Buildings can make marvellous subjects in their own right: think only of a jumble of period buildings clustering round a medieval church, or groups of weathered fishermen's cottages fringing a stone harbour, to realise something of their potential. It is also true to say that buildings are such a vital feature of the countryside that even those whose prime interest is the unspoilt rural landscape must learn how to paint them convincingly.

In this book, I shall look at different types of buildings and examine how best to convey them in fresh, transparent watercolour. My aim is to capture their essence and atmosphere in full, liquid washes, rather than to paint in every detail with a tiny brush. Some knowledge of perspective is essential because of the geometric shapes of buildings, and aerial perspective is also important. Composition is important too: a badly-composed painting, however brilliant the brushwork, will always be a bad painting. I shall also consider the different styles and periods of architecture, as well as ways in which to convey the effects of age and weathering. Urban and industrial buildings will be included, showing what wonderful subjects they can make when handled with imagination and understanding. My main objective throughout will be to use the wonderful medium of watercolour correctly, so that the paper shines through fresh clear washes, without a hint of the muddiness and dullness that are the result of laborious overworking.

Ray Campbell Smith

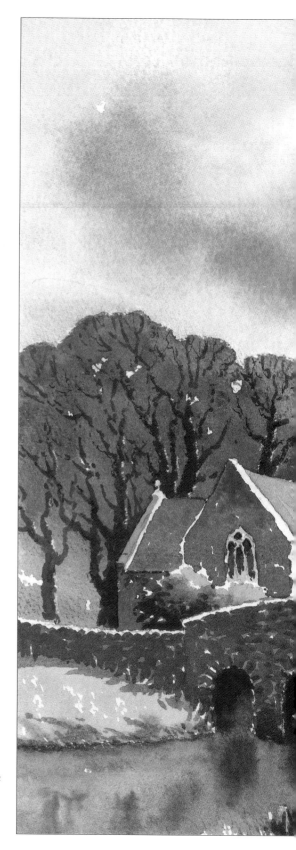

6

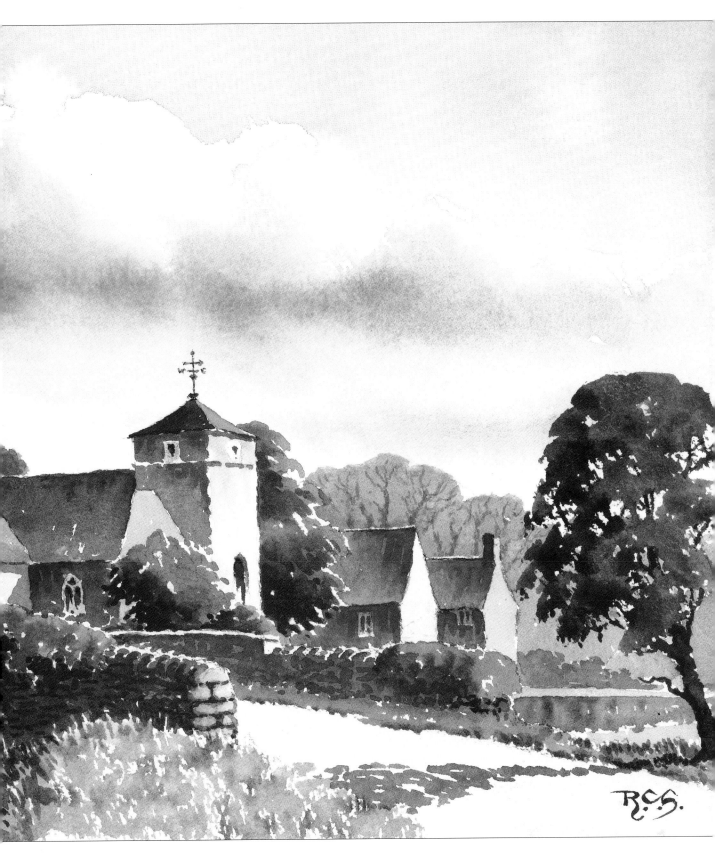

Materials

In the studio, I use a larger paintbox which includes four deep mixing wells. For mixing large washes I have a collection of white dinner plates. In the field, weight is important, so take only the essentials. My ideal kit is a small paintbox with up to ten pans; a light plastic mixing palette; two screw-top jars of water; some cotton rag or absorbent paper; a 25mm (1in) flat or mop brush; three round brushes (Nos. 6, 8 and 12); a 2B pencil and a putty eraser, safely packed in a small haversack. I attach paper to a small drawing board with drawing pins or masking tape and protect it in a plastic envelope. Take a small folding stool, or a lightweight metal folding easel. If creature comforts figure on your list of priorities, add a vacuum flask and some insect repellent!

My canvas haversack: all my outdoor painting equipment fits in this.

Paper

Using paper that really suits you is a tremendous help: experiment until you find your ideal. My favourite cotton rag papers are available in three finishes: smooth or hot pressed (HP); slightly textured or cold pressed (CP) which is also known as Not, and rough. I prefer rough for most of my work, as its texture and 'tooth' help with various watercolour techniques. I use 600gsm (300lb) weight which is resistant to cockling when liquid washes are applied. All the paintings in this book are on this paper, in my preferred quarter Imperial size (280 x 380mm or 11 x 15in). Note that any paper below 425gsm (200lb) in weight should be stretched.

Paints

I use paint from tubes because it is more responsive. I squeeze generous helpings into the pans in my paintbox before I start work on a painting, so nothing is wasted and I always have soft paint. I prefer artists' to students' quality paint for its greater clarity and brilliance; in this fascinating but capricious medium we need all the help we can get!

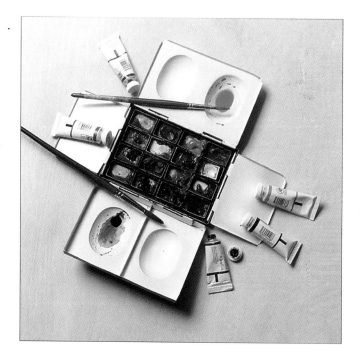

My well used paintbox, with 14ml tubes of artists' quality paints.

Brushes

The size of brushes you will need will depend largely on the scale of your work. For paintings of quarter Imperial size (280 x 380mm or 11 x 15in) or half Imperial size (560 x 380mm or 22 x 15in) the minimum you will need is one large brush (a 25mm or 1in flat, or a mop for large areas such as skies) and three round brushes, perhaps a No. 6, a No. 8 and a No. 10 or No. 12. Kolinsky red sable is traditionally the best because of its shape-retaining qualities and springiness, but some of the modern synthetics are not far behind.

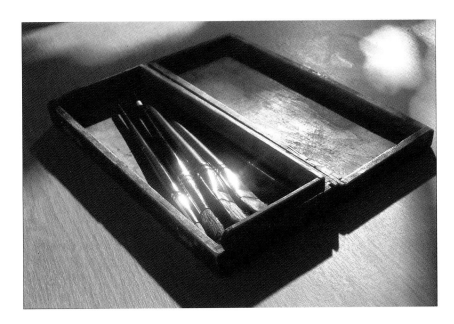

The ancient box I keep my brushes in

Other equipment

A **putty eraser** does less harm to the delicate surface of watercolour paper than the plastic or rubber variety. Erase pencil lines when your work is completely dry. **Masking tape** and **masking fluid** are handy additions that are used to protect small areas from large washes, such as white seagulls against a stormy sky or, as on page 29, the darker wall of a building. I use a **craft knife** to sharpen pencils, and also to scratch out highlights. For sketching, I usually choose a **2B pencil**, but occasionally I use a **fibre-tipped pen**, a **technical pen** or even a **fountain pen**.

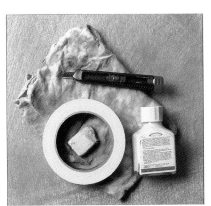

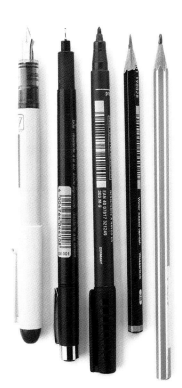

Putty eraser, masking fluid, masking tape, craft knife and cotton rag.

A selection of pens and pencils

Colour and tone

The ability to produce a colour at will comes with experience, and some knowledge of elementary colour theory is important. The three primaries, red, yellow and blue, cannot be made by mixing any other colours. Secondary colours are made by mixing any *two* primaries: red and yellow for orange; yellow and blue for green and blue and red for purple. Secondaries will vary according to the proportions of constituent colours; for example, mixing more yellow than red in the first pair will produce warm yellow rather than true orange. Mixing the three primaries in roughly equal proportions will result in dull grey or brown, but delightfully subtle shades can be made if one colour is allowed to predominate.

Colour temperature

Colours may be classified according to 'temperature'. Warm colours are those of fire: reds, oranges and yellows. Cool colours are those of shadows falling on snow and ice: cool blues and greys. In landscapes, warm colours naturally come forward and cool colours recede. Foreground grass will be a warm green, containing plenty of yellow, while more distant fields will have a definite bluish tinge. Distant hills will appear a soft blue grey. This is part of the theory of aerial perspective – see page 20.

The colour wheel

Look at the colours immediately opposite each other in this simple colour wheel: red and green; yellow and purple; blue and orange. These 'pairs' of colours are also opposite in character, and produce a striking effect when they are placed side by side – the classic example is a figure dressed in red against a green background. When they are mixed in roughly equal proportions, these colours also produce dull greys.

The simple colour wheel

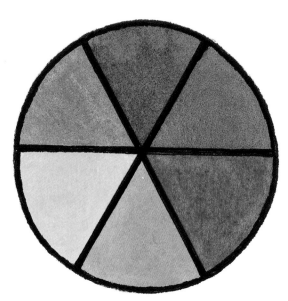

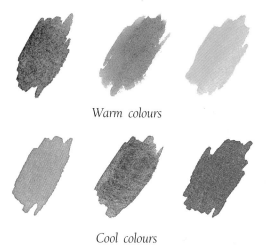

Warm colours

Cool colours

The limited palette

I firmly believe that limiting your palette to a few colours enables you to understand their foibles and qualities really well. More importantly, it helps work to 'hang together'. My basic landscape palette, which is also suitable for buildings, is raw and burnt sienna, light red and French ultramarine and Winsor blue, green shade. I sometimes add raw and burnt umber, Payne's gray and alizarin crimson. For very sunny scenes I may add one or more of the cadmiums: yellow, orange or red. I find made-up greens too bright and artificial and prefer to mix my own, usually with Winsor blue, green shade and either raw sienna or cadmium yellow.

Tone

In this context tone does not mean colour, but simply the lightness or darkness of a colour. For paintings to succeed, they should contain plenty of tonal contrast, and lights should be placed against darks whenever possible. Painters can move the scenery about to achieve the desired result: a whitewashed cottage against a pale sky makes little impact, but the same cottage with a stand of dark trees behind it will register strongly.

The painting of a street market in Provence, France (below) is all about colour and tone: the assortment of market produce provides plenty of bright colour, while the sunlit umbrellas contrast strongly with their shadowed background.

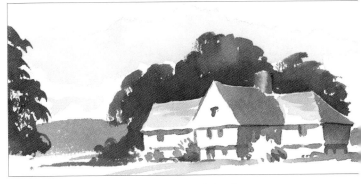

It often pays to make a preliminary tonal sketch to sort out the placement of lights and darks.

Street Market, Provence
This painting is all about colour and tone.

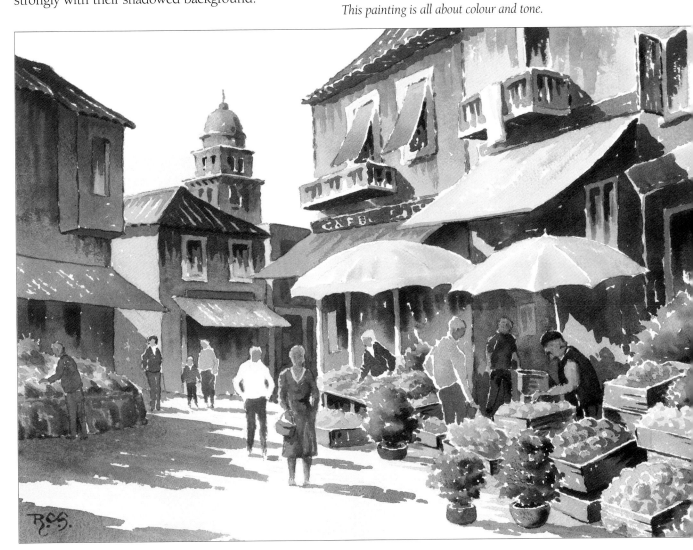

Techniques

The beauty of watercolour depends entirely on correct technique: if it is applied incorrectly, its fresh transparency is lost and muddiness rears its ugly head.

A common beginner's error is to apply pigment straight from the pan without preparing a wash, losing vital freshness in the process. Whatever the size of the area to be covered, watercolour should always be applied as a well-mixed wash. The colour or colours should be added to a pool of water, a little at a time, until the required colour and tone are obtained. The resulting wash should be applied as quickly as possible. The simplest type of wash is the flat wash, which is used to cover an area of any size with an even film of pigment – see below. If you work quickly and well, the result will be smooth, even colour. If you work too slowly or unevenly, the result may look stripy. One way to avoid this is to dampen the paper evenly all over before applying paint. If you do, strengthen your prepared wash a little to compensate for the diluting effect of the dampened surface.

Flat wash

For a large area such as the sky, set the board at an angle of about 15° from the horizontal. Load the brush fully and draw it across the top of the paper so that a bead of liquid collects at the lower margin of the stroke. Pick this up on the following stroke and so on right down the paper. Beginning successive strokes from alternate sides helps to make the distribution of pigment more even.

Graded wash

This technique is useful for painting clear skies. It is similar to the flat wash, but instead of dipping the brush in the prepared wash between each horizontal stroke, a gradually increasing proportion of pure water is taken up as you work down the paper. This steadily dilutes the original wash and the result should be a gradual and even lightening of the tone.

Variegated wash

This is a variation of the graded wash but using a second pool of colour instead of water. The proportion of this is gradually increased with successive horizontal strokes, resulting in the smooth blending of the first colour into the second. This technique is also useful in painting clear skies where the blue may blend smoothly into a warmer shade above the horizon.

Broken wash

This technique is often used to indicate texture, and works far better on paper with a rough surface. The prepared wash is applied with a large brush held almost parallel to the paper, and drawn rapidly and lightly across it. The brush skates over some of the little hollows in the surface, leaving chains of tiny white dots in its wake. Do not load the brush too heavily or all the little hollows will fill with paint.

A tree in full leaf

It takes time and practice to perfect the broken wash technique but its usefulness in suggesting texture economically makes the effort worthwhile.
A variation of the broken wash will enable you to capture the ragged outlines of trees in full leaf.

Dry brushwork

This technique is similar to the broken wash but entails picking up less of the prepared wash with your brush. Texture is then applied, perhaps to indicate tree bark or a rough stone surface. If your brush is *too* dry, freshness will be lost and muddiness will creep in.

Wet in wet

This technique enables the watercolourist to
capture the wonderfully atmospheric effects
of mist and fog, and to paint objects with
soft edges fluently and effortlessly. If, for
example, you want to capture an impression
of woodland in misty conditions, the
procedure is this: first apply a pale wash of an
appropriate colour all over the paper, then start
dropping, into the wet surface, washes to represent the trees.

Wet in wet

The first strokes into the wet surface will spread palely with very soft edges to
convey a good impression of more distant trees. As the surface gradually becomes
drier, subsequent strokes will appear darker and more precise, and may be used
for the nearer trees. When the surface of the paper is completely dry you must
stop painting, unless you require hard-edged trees in the foreground.

There are two important points to bear in mind. Firstly, the applied strokes
must be less liquid than the paper's surface, or cauliflowering will occur and
ruin everything. Secondly, you must prepare all your washes in advance as there
is no time to do so while the paper's surface is drying.

This technique is not quite as easy as it sounds and demands much practice,
but opens up a whole range of stunning atmospheric effects and should be added
to your repertoire.

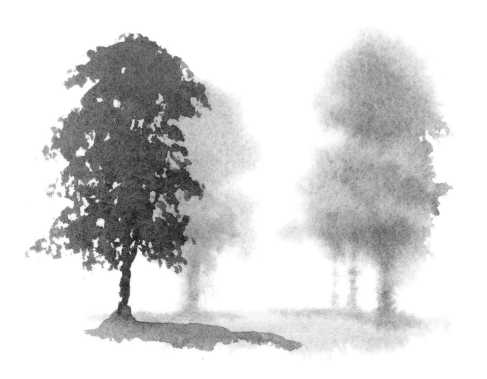

Misty woodland

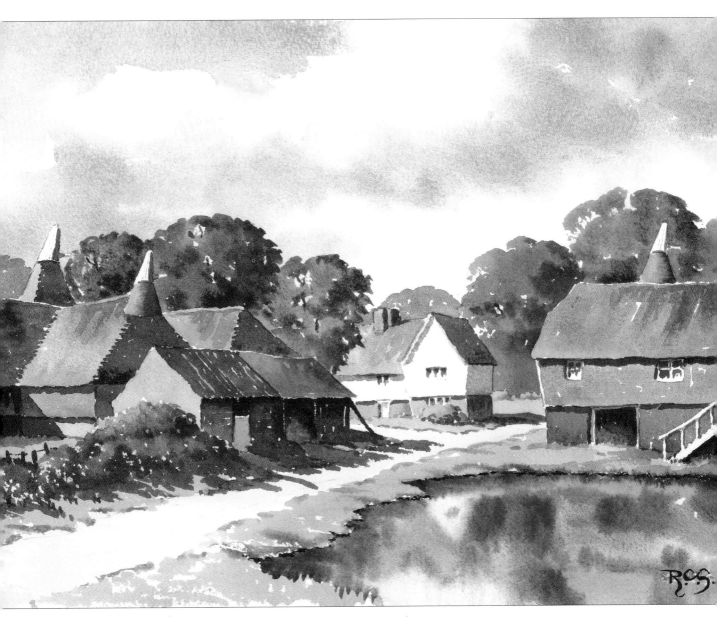

Frittenden Oasts

Flat, variegated and broken washes all feature in this painting, while the wet in wet technique produces the soft-edged reflections in the farm pond. A tonal sketch often helps to sort out and make the most of lights and darks – see page 11.

Weathered brickwork

Dressed stonework

Reflected light in shadow

An old colour washed wall

Signs of rising damp

Weathering and texture

Finding effective ways to capture the appearance and texture of building materials is vital. Flat washes of an appropriate colour may be fine for buildings in the middle or far distance, but for those in the foreground a flat wash does not convey nearly enough information about elements like bricks or stones. More detail must be included, but how much more? Painting every brick or stone will probably make the treatment look overworked, too detailed and fussy. The middle way is usually best: including enough detail to establish the building material, but leaving much to the imagination.

There will usually be some local unevenness of colour or tone in the building materials, and for variety it may help to exaggerate this. If the building is old it will show signs of age and weathering to which full justice should be done. For a section of brick wall, include some bricks but do not painstakingly include every one – the imagination of the viewer should do that. A similar approach works equally well with walls made of stone, whether with a natural or a dressed finish. Rendered and colour washed walls present different problems. To give them character look for signs of weathering, blemishes and so on. Indicate some of these with hard-edged washes, some by soft-edged washes and others by broken washes. Buildings flanking rivers or canals and brick and stone bridges will probably show traces of green algae on their damp lower courses: these too should be firmly indicated.

The colour of building materials is affected by the quality of the light, and paintings should demonstrate whether the scene was set in the cool light of morning or the warm light of evening. Particular attention should be paid to shadows on masonry: do not paint them all the same colour: there may be warm, reflected light from a nearby sunlit road or wall which should be shown.

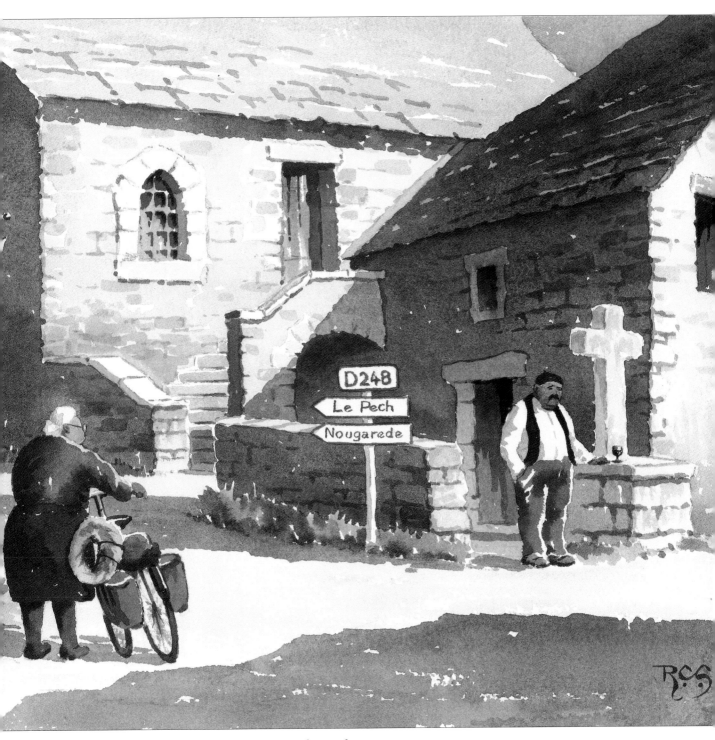

Crossroads, Dordogne

The weathered masonry and stone slates of this splendid old building made a fascinating subject. Note how I used variations in colour rather than a flat, uniform grey to suggest moss, algae and warm reflected light on the stonework.

By kind permission of Leisure Painter

17

Perspective

The solid geometric form of buildings means that it is vital to get to grips with the basics of perspective theory. Perspective theory is based on the obvious fact that distant objects appear smaller than near ones. It is important to have a firm idea of where the eye level line would be in the landscape, even though in practice hills, trees and buildings often obscure the true horizon. At sea there is no problem, as our eye level line is clearly the observed horizon; this is also true of a dead level plain. The examples below outline the basic principles that should provide you with the knowledge both to draw buildings in correct perspective and correct those that are not.

Diagram A (below) considers a line of posts of equal length, equally spaced and stretching in a straight line to the horizon. It is clear that the line of posts will appear to vanish on our eye level line at what is termed the vanishing point, shown as VP on the diagram.

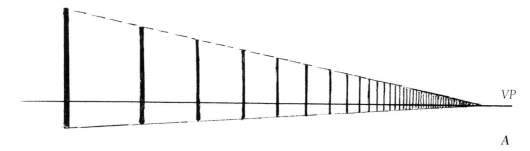

A

Solid constructions

Imagine a solid object, such as a hut with a flat top. Each of its visible sides will have its own vanishing point, and you now have the simple construction with which to check the perspective of any solid rectangular figure. Simply extend the lines forming the tops and bottoms of the two visible sides until they meet and, if the drawing is accurate, they will meet at the two vanishing points on the eye level line, or true horizon – see diagram B, below. It is clear from the drawing that lines above our eye level line will slope down from the nearest corner of our hut, while those below it will slope up.

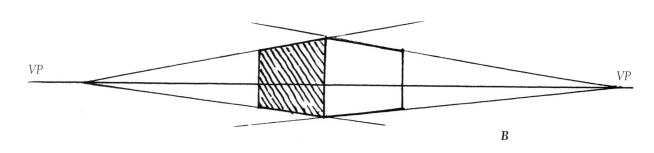

B

Simplifying the shape of buildings

Most buildings are more complex than in the previous example, but they can all be simplified into single solid rectangles which can be dealt with individually. It is worth noting that the nearer the hut, the steeper the perspective lines and the more distant, the flatter they will appear to be, as shown in diagram C, below.

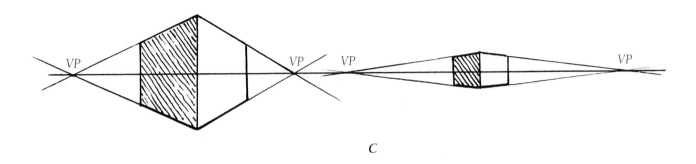

C

Rectangles

The final diagram, example D, illustrates the construction of solid rectangular objects wholly above or wholly below our eye level line.

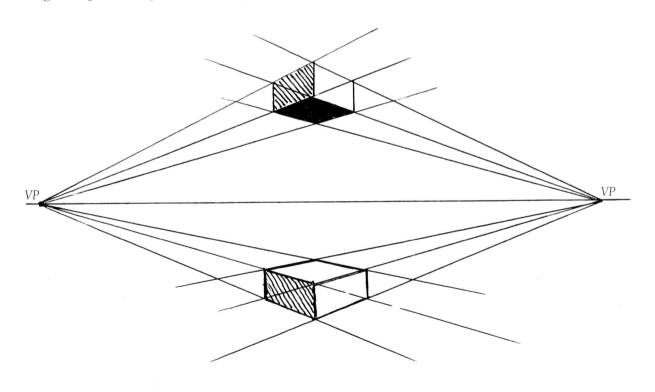

D

Aerial perspective

A. Distance reduces tone and tonal contrast.

Aerial perspective has little in common with linear perspective, but relates to the effects of distance including the softening of edges, the reduction in tone and tonal contrast, and the cooling of colours.

There is usually some water vapour in the atmosphere, which on humid days is visible as mist. In towns and cities, added smoke and dust reduce visibility still further – before the introduction of smokeless zones, the result could be dense fog like the legendary London smog. This means that distant objects look softer and more ethereal than nearer ones, and this will help to create a feeling of recession if it is shown in paintings. Distance reduces tonal contrast so there is far less difference between lights and darks on the horizon than in the foreground. A flat, blue-grey wash is often enough to render accurately hills in the background – see example A. Distance also tends to lighten tone, so the background is usually several tones lighter than the foreground. It also filters out 'warm' colours leaving just cool blues and greys. These changes in tone, colour and colour temperature occur gradually as distance increases and should not be illustrated too abruptly – see example B.

Occasionally on very clear, dry days, there appears to be no mist in the atmosphere, and the distance looks as clear and crisp as the foreground, yet painted literally, it will look thoroughly unconvincing. This is where artistic licence – the addition of a little imaginary aerial perspective – is justified.

B. A touch of raw sienna in the lower slopes of the distant hill helps to link it to the warmer colours of the foreground.

Flood Tide Below Rye

This impression of the old Sussex port is a good example of aerial perspective. I painted the landmark church tower, medieval keep and jumbled buildings using a single modified blue-grey wash of French ultramarine and light red, with wet in wet additions of light red and raw sienna to suggest areas of brick and foliage. When this base wash was dry, I added shadows in French ultramarine and light red to indicate the shapes of a few individual buildings. Strong, contrasting tones were used for the foreground boat and landing stage, to make them come forward and so make the town recede into the background.

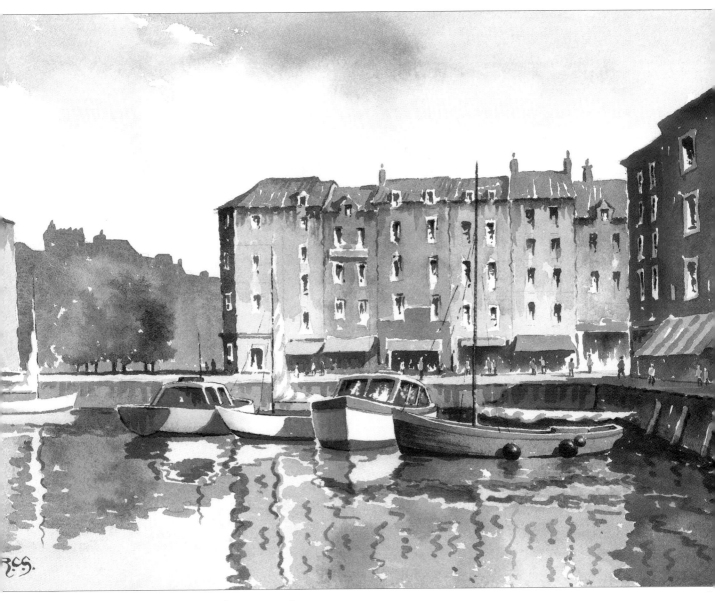

Mediterranean Scene

I used the white of the paper for the sunlit areas of the lively cumulus clouds, merging softly into the pale French ultramarine and light red of the cloud shadows. For the pantiled roofs I used various mixtures of light red, burnt sienna and a little French ultramarine, with brush strokes that followed their shape and so roughly suggested the lines of the tiles. I used paler blends of raw sienna, burnt sienna and cadmium orange for the colour-washed walls, with pale, vertical brush strokes of French ultramarine and light red added, wet on dry, to indicate texture and weathering and a stronger French ultramarine and light red wash for the walls in shadow. For the trees, I used fairly strong washes of raw and burnt sienna and Winsor blue, green shade, with shadow of Payne's gray and burnt sienna added wet in wet. The reflections are hard-edged and the images of the inverted buildings and boats are indented to suggest the rippling surface of the water. A few figures were added to provide a little human interest. The nearer boats were painted in strong tones to bring them forward.

Composition

A. Try to avoid cutting your painting in equal halves with dominant horizontal or vertical lines.

In drawing and painting, the term composition refers simply to the arrangement of the elements of the scene, so that it produces a pleasing and harmonious overall effect. It is often a good idea to examine a view from a number of different angles. When seen from another viewpoint, buildings that are strung out in a straight, uninteresting line may well begin to overlap and relate to one another in a far more attractive way, to produce a more pleasing composition.

When planning a composition, avoid cutting a painting into equal halves either horizontally or vertically, for example by placing a horizon mid-way, or a church steeple centrally – see example A. Avoid anything that carries the eye out of the painting, such as a foreground road, track or river. A clump of bushes, placed strategically, may well serve as an effective blocking device – see example B. 'Moving' objects should appear to be going into the picture rather than out of it, again to keep the viewer's eye on the painting – see example C. Try to balance the painting so that all the tonal weight is not on one side: adding heavy cloud cover on the opposite side may well do the trick – see example D. Try to include a focal point or centre of interest, and if you can make some of your main construction lines point in its general direction, so much the better. Where possible, avoid two or more competing centres of interest – see example E. Look out for tonal contrasts as these will add punch to your work; place lights against darks if you can, even if this involves changing the positions of some of the elements in your subject – see example F. Inexperienced painters may be so keen to get down to the business of applying paint that they devote too little time to preliminaries, and overlook more promising compositions. If literal accuracy is not essential – as it may be in a commissioned work, or a picture of a particular place – there is nothing wrong with rearranging the landscape to improve the composition!

B. Avoid allowing any feature to carry the eye out of the painting.

C. Remember that boats, walkers, horses and so on should move into, not out of, your painting.

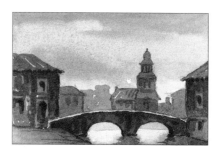

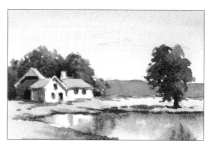

D. Try to balance your composition. Heavy clouds may balance dark features on the other side of the painting.

E. It usually pays to have a focal point or centre of interest and it helps if some of your construction lines point towards it.

F. Look for tonal contrast whenever it occurs.

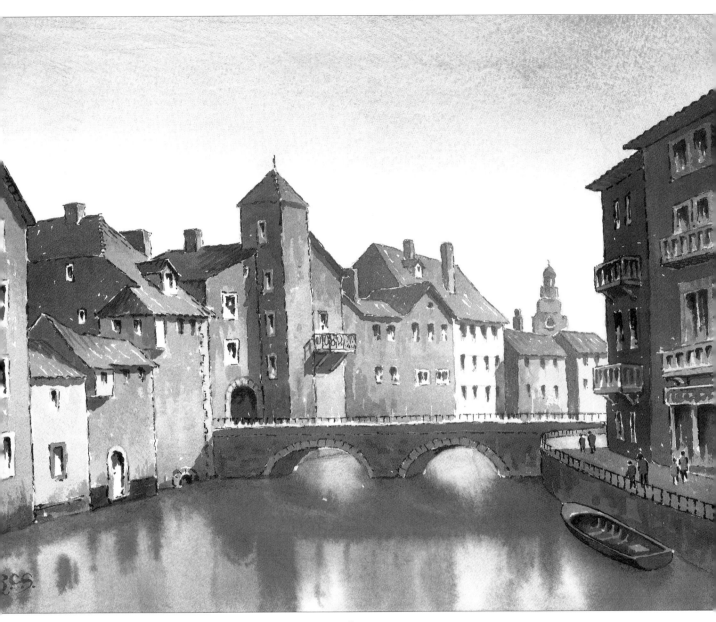

Canal Scene

The variations in shapes and heights of the buildings that fringe the canal provide an interesting but complex skyline. The soft treatment of the reflections below provides a restful, contrasting area. The sunlit buildings on the left are balanced by the deep-toned buildings on the right.

Architectural details

The shape and design of details such as windows, doors and chimneys will vary according to the style of building, and careful observation will help to ensure accurate drawing. It is a good idea to familiarise yourself with architectural styles including Tudor, Jacobean, Carolean, early, middle and late Georgian, Victorian, Edwardian and contemporary. This need not involve detailed study, but it helps to have a broad idea of what to look for: the stone mullions of the Jacobeans, the pleasing proportions of the Georgians, the confident and sometimes florid approach of the Victorians.

Manufacturing methods have improved progressively in the centuries since the first use of glass. It became possible to make glass in increasingly larger sizes, which naturally had an impact on window design. Early windows were made up of many tiny rectangular or diamond-shaped panes set in lead lattice. Later, larger panes facilitated delightfully proportioned Georgian windows, while with even larger sheets of glass at their disposal, the Victorians were able to do away with glazing bars. Today, 'picture windows' often make the most of pleasant views. It is not necessary to paint windows in precise detail and it is usually better to indicate them fairly broadly. The important thing is to avoid making them all look exactly the same. Sometimes you can see into a room; sometimes the glass reflects the light, or perhaps a bit of both. There may be draped or drawn curtains. Use these differences to achieve variety in your treatment.

Introduce variety into your windows

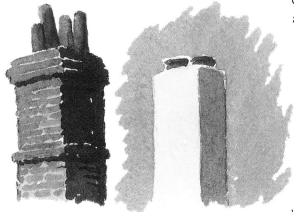

A traditional chimney and a contemporary chimney

Chimneys and their stacks can also vary greatly with architectural styles, from ornate and decorative Tudor designs at one extreme to stark contemporary styles at the other. The pitch of roofs also varies greatly, from steep Jacobean slopes to the far gentler Georgian slopes. The amount of detail of guttering, downpipes and other features you include will depend on the proximity of the building, but make sure you put in all the shadows as these help to give shape and solidity.

Creepers and adjacent trees and shrubs also need careful handling. They can provide useful tonal contrast but should not be allowed to obscure too much of the building – and remember that they, too, cast shadows.

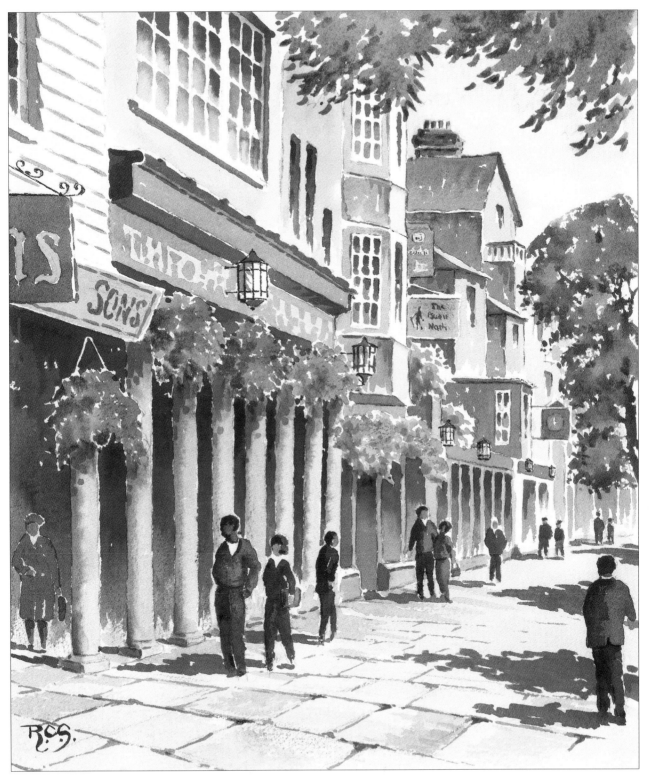

The Pantiles, Tunbridge Wells

The assortment of periods and styles in this fascinating jumble of buildings provides
an interesting variety of architectural details which have been painted fairly loosely.

Farm Buildings

The British countryside is rich in farm buildings, many of them constructed before mass transport when building materials had to be obtained locally. This gave buildings of all kinds their strongly regional flavour and much of their period charm. The Wealden clay of south-east England was used extensively for colourful bricks and tiles with glowing red, brown and orange tints; limestone provided the attractive honey-coloured building material characteristic of the Cotswolds; in the north, harder rocks contributed greatly to the rugged, uncompromising appeal of rural architecture, while in wooded or lowland areas timbered or half-timbered buildings were the norm. These buildings seem to have settled naturally and harmoniously into the countryside, adding to its beauty and character. Sadly, some modern farm buildings are very different, and are constructed more cheaply in a manner that often suggests light industry rather than farming. Landscape painters will continue to seek out the older, traditional farms for their subjects. Below is a small Cumbrian farmhouse and opposite an example of the older type of Wealden farm beloved of so many painters and painted on the spot in early autumn.

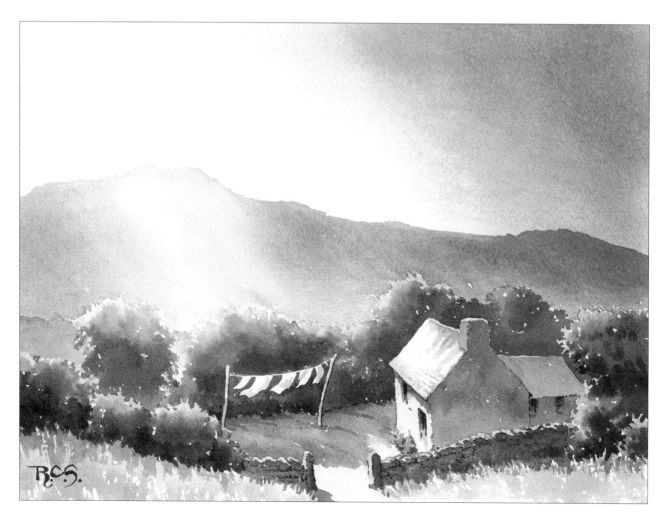

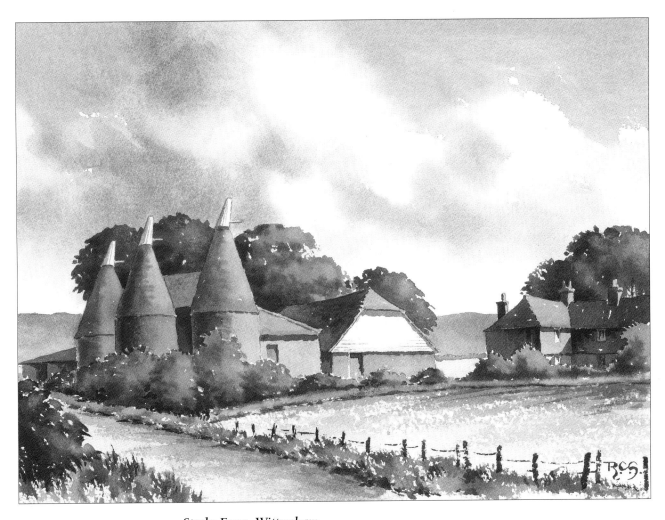

Stocks Farm, Wittersham

The afternoon sunlight from the right helped to give the jumbled buildings of this farm, with its warm bricks and roundel oasts, a three-dimensional appearance with plenty of useful tonal contrasts. The sunlit elevations of the buildings registered effectively against the dark trees so I placed one behind the white gable for additional tonal contrast. The lively cumulus sky went in first, with washes of pale raw sienna for the lower sky; French ultramarine and light red for the cloud shadows, and Winsor blue and French ultramarine for the blue sky. I let these washes blend softly, but retained some hard edges. The sunlit brickwork and tiles were various pale blends of light red and burnt sienna, with touches of green in the lower courses to suggest moss and algae. The shadowed walls and roofs were mainly light red and French ultramarine, with a little texture added, wet on dry, in deeper tones of the same wash. The distant hills were a wash of French ultramarine and light red, with a hint of raw sienna on the nearer slopes.

Some of the foliage had a hint of russet so I used burnt sienna, with a little raw sienna and Winsor blue, green shade, with strong shadows of Payne's gray and burnt sienna for the green foliage. A broken wash of raw sienna with a little added light red served for the pale tones of the foreground ploughed field, with added light red and French ultramarine texturing. The foreground features – the tussocky grass and line of fence posts – were put in fairly loosely so that they would not demand too much attention. Even the smaller passages were applied as liquid washes which helped to preserve the freshness and transparency of the paint.

Opposite

Cumbrian Farmhouse

This small farmhouse nestles into the hillside. Misty sunlight from the left touches everything with its warm glow, catching the tops of the trees, the line of washing, the slated roof and the dry stone wall in the foreground to create plenty of tonal contrast.

Fishermen's cottages and harbours

The older fishing villages in the West Country, with cottages clustering round sturdy stone jetties, make irresistible subjects. With their random, unplanned grouping, the buildings seem almost part of the natural scene; weathered, rugged and permanent. The port of Newlyn became a magnet for artists inspired by the unspoilt beauty of the coast, and the Newlyn School attracted many fine painters. There are many other delightful fishing ports on Britain's coastline, all with distinct regional characteristics, and well worth the attention of landscape artists.

Polperro is one of Cornwall's most popular and attractive fishing ports. My viewpoint from the inner harbour focused on the jumble of harbourside cottages, with just a strip of water and a few moored boats in the foreground. When painting groups of buildings, the direction of light is vital. Here, it was coming from the right: the resulting pattern of light and shade gave the cottages form and shape. In a subject like this, varying the treatment of windows is vital: fifty identical rectangles would be a disaster! I added a few roughly-painted figures for human interest, concentrating on posture rather than detail. The three moored boats contrasted effectively with their dark background.

Polperro

I made a quick, exploratory sketch, then drew the shapes of the buildings, paying careful attention to perspective. Working from light to dark, I began the sunlit elevations of the cottages. These were mainly the white of the paper, with pale broken washes in places to indicate texture and weathering. I used pale tones for the sunlit, slated roofs, and made the most of colour differences, adding the greenish tinge of moss and algae to the lower courses. For the rough stonework of the cottage on the left I used a broken wash in a mix of burnt sienna and French ultramarine, and added a few random blocks of stone to the adjoining harbour wall. The cottage walls in shadow contrasted effectively with the sunlit elevations and helped to give the buildings a solid, three dimensional appearance, while the dark foliage of several trees made even stronger tonal contrasts with the adjoining whitewashed walls. I used masking fluid on a shadowed wall to preserve the shapes of two seagulls in flight. I emphasised the greenish local colour of the water to distinguish it from the scene above, and indicated the reflections very loosely, giving them indented outlines to suggest the gently rippling surface. I completed the painting with a few final touches, but these should be kept to a minimum and any urge to 'tidy up' strongly resisted!

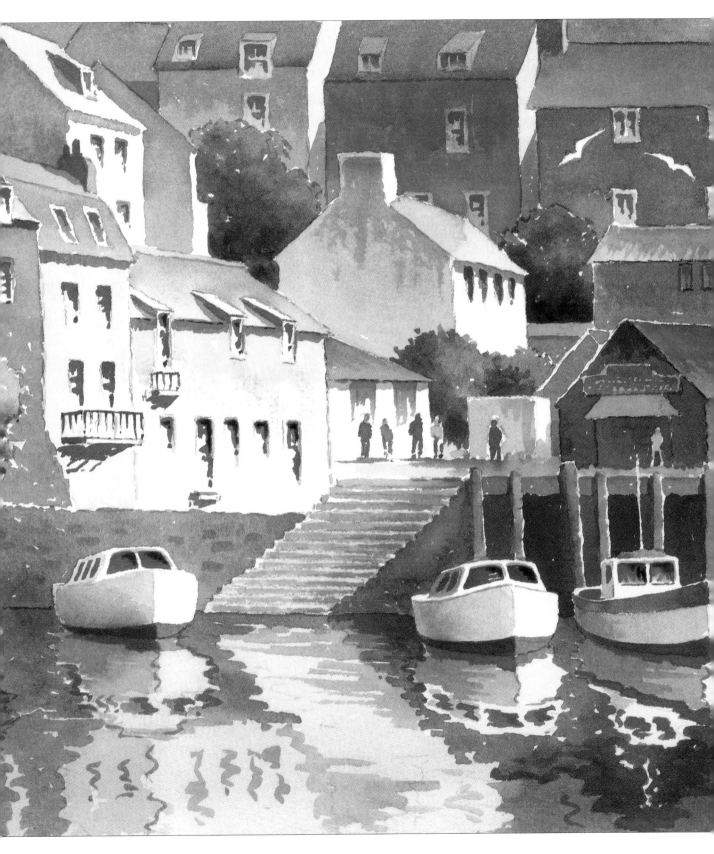

Industrial buildings

Most of us live or work in towns and cities, so it is understandable that we should seek relaxation, recreation and inspiration away from bricks and mortar. Our countryside is under constant threat and artists should record its character and beauty while they can. Many landscape painters seek inspiration exclusively from the natural world and set off automatically for the countryside in search of subject matter. One disadvantage of this preoccupation with rural landscapes is that it may close our eyes to promising subjects nearer home.

Artists should be sensitive to all types of visual stimuli and should not limit their artistic efforts to the conventionally picturesque. They may perceive form and beauty where others see only squalor, and their paintings invite others to share their vision. On grey days city scenes may seem dull and drab, and lack visual appeal, but a dramatic industrial skyline against a fiery evening sky could pose an exciting challenge to the imaginative artist. The meanest back street, with light from shop fronts and windows reflected in its wet surface, may inspire an impression rich in atmosphere and feeling. The painting opposite shows the corner of an undistinguished East London street with a few run-down shops and not much else, but something about the contrast between the warm light from the shops and the grey, mizzling atmosphere beyond caught my attention.

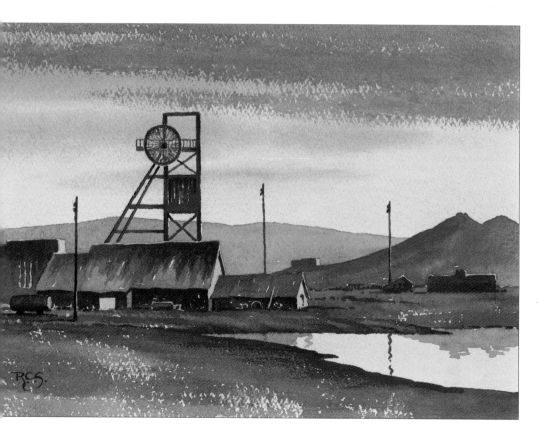

Coal Mine

I painted this impression of a small Welsh coal mine in warm sunset tones, using just three colours: raw sienna, light red and French ultramarine. The buildings and machinery are strongly lit by the sunset glow from the right, and the pithead stands out starkly against the fiery sky to increase the dramatic impact.

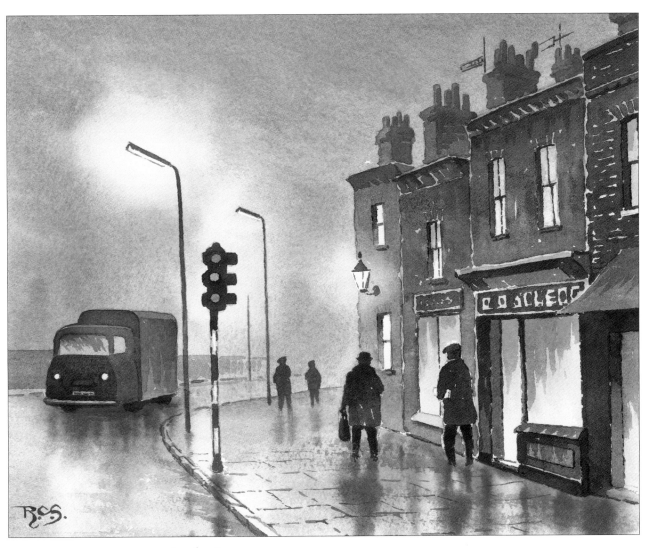

London Smog

When I saw this scene, I made a mental note of the haloes cast by the lamps in the damp mist and made a scribbled sketchbook note of the road, the buildings and the figures hurrying home to their firesides. Back in my studio the impression was still vividly in my mind so I sketched out the scene and set to work. I used masking fluid for the street lights, the lorry headlights, the traffic lights and the lighted windows. While it was drying I prepared a wash of raw sienna and a little light red for the glowing haloes of the lights, and one of French ultramarine and light red for the misty background. I applied both with large brushes and allowed them to blend softly, allowing for the fact that watercolour fades appreciably on drying.

I removed the dry masking fluid with my fingertip, then painted the warm lights in the windows, again in raw sienna and light red. The buildings were various deeper combinations of light red, burnt sienna and French ultramarine and I left a few chips in the wash applied to the nearest shop to suggest brickwork. I applied a pale wash of light red and French ultramarine to the pavement and roadway, then dropped in several vertical strokes of a deeper version of the same mixture, wet in wet, for some reflections in the wet surface. When the paper was again dry. I added some detail – the kerb, the paving stones and a little broken wash texture. The lorry, the lamp standards, the traffic lights and the figures, all in deeper tones, completed the painting.

Mediterranean buildings

The natural scenery and the architectural heritage of the lands bordering the Mediterranean provide a wealth of subject matter for the painter. There is a great diversity of styles, but a typical building will have a low pitched, Roman tiled roof and a plaster or stucco façade, perhaps colour washed in ochre or terracotta. In the enchanted city of Venice buildings of this type abound, and there seems to be a compelling subject round every corner. I chose the scene opposite because it contained a mass of buildings of different shapes and sizes and a fine church to act as the focal point. The elegant footbridge prevents the eye being carried off the paper by the curving canal; several of the main construction lines carry it instead towards the church. In compositional terms the dome may be rather too central, but the white church building to the right is perhaps just sufficiently off-centre.

For the water in the painting below, I decided to use hard-edged reflections. For a more complex composition, I generally choose soft-edged reflections, dropped wet in wet into a moist base wash, so they complement the scene but do not compete for attention. In a busy painting, a soft area of this sort gives the eye a welcome resting place.

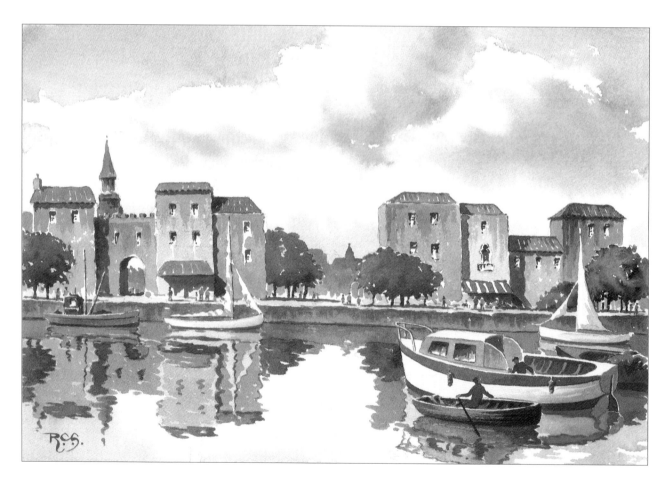

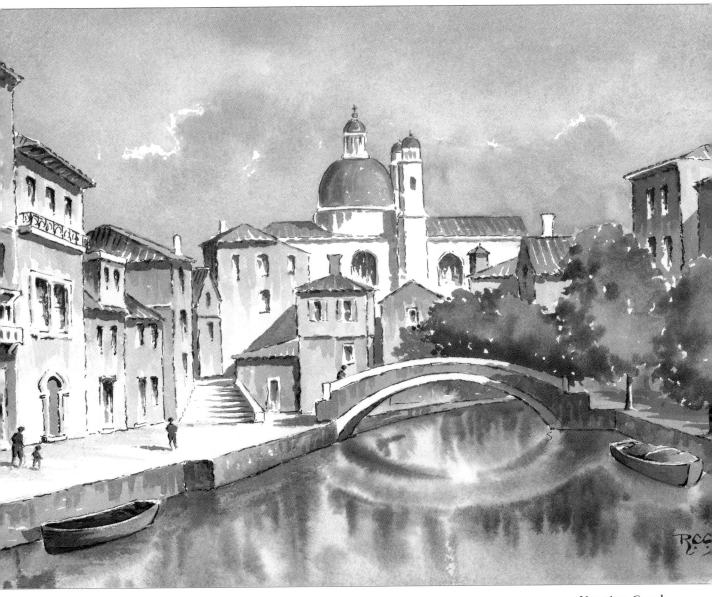

Venetian Canal

I sketched in the main elements quickly, balancing the buildings on the left with a line of trees in deeper tones to the right. There was a heavy heat haze and distant thunder clouds, so I used washes of French ultramarine, light red and some alizarin crimson. The resulting purplish shade was roughly complementary to the warm colours of the sunlit buildings so it made an interesting chromatic contrast. The church walls were just the white of the paper, except for some grey shadows and pale texturing here and there.

Opposite

Mediterranean Waterfront

In this painting the reflections are hard-edged and show the scene above inverted, albeit with indented rather than straight edges to suggest the rippling surface of the water. The colours are similar to, but a little less bright than those of the objects above.

Grand buildings

Many buildings fall into this category, from cathedrals, castles and stately homes to town halls. Architectural styles may range from elaborate ecclesiastical Gothic to the more severe lines of the classic and neo-classic tradition. Watercolour is not at its best when used to describe the minute detail of carved stone embellishments; aim instead to capture the impact and grandeur of the subject, suggesting the mass of detail as economically as possible.

I made the most of the impressive lines and unique situation of Notre Dame (opposite). I made a preliminary sketch, with the cathedral off-centre, leaving plenty of space for the sky. It was a fine evening in late summer and the warm glow from the cloudless sky touched every part of the scene, including the foreground trees which showed hints of autumnal russets. The cathedral made a strong statement against the sky and the sunlit bridge registered equally strongly against the darker background. I exaggerated the lights and darks a little for tonal contrast. I gave the water a simple wet in wet treatment in soft, pale tones to complement but not compete with the scene above, and capture something of the soft reflections in the river. Note how the light catches the tops of the trees and embankment parapet: it is touches like this that help to bring paintings to life.

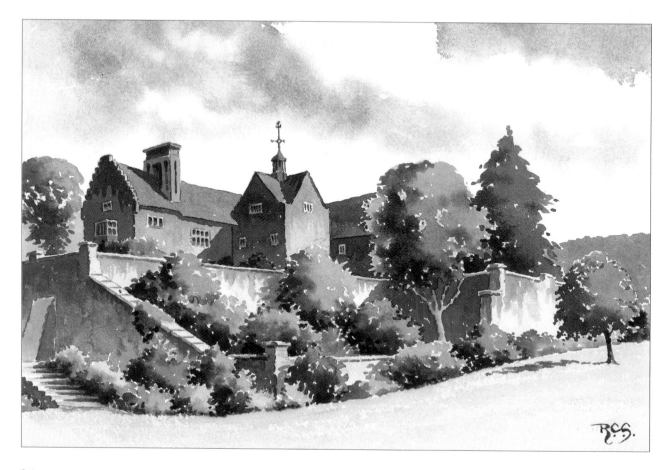

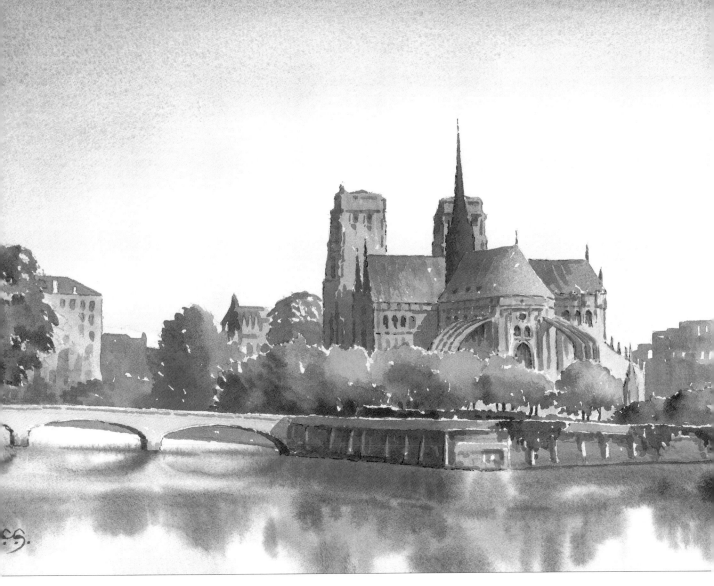

Notre Dame, Paris

I prepared a wash of raw sienna with a touch of light red for the warm lower sky area and one of French ultramarine and a little light red for the upper sky. With my board upside down and a large brush I began to apply the first wash, picking up and applying an increasing proportion of the second as I worked downwards to achieve a smooth transition and blending. I let the paper dry, then started to paint the buildings on either side of the cathedral in stronger versions of the sky washes. I used raw sienna and light red for the glow of sunlight on the cathedral masonry, adding a little French ultramarine for the towers, which looked darker against the pale sky. I added shadow and some texture, wet on dry, with a wash of French ultramarine and light red, using a stronger mix for deeper shadows, the spire, windows and other details.

The slate roofs were a warm grey mix of French ultramarine with a little light red. I left a space with a broken edge for the tops of the trees below, then added them, quickly and boldly, using various washes of raw sienna, burnt sienna and Winsor blue, green shade, with a deeper wash of Payne's gray wet in wet for the shadows. I used a very pale wash for the sunlit bridge and deeper tones of French ultramarine and light red for the embankment, particularly the shadowed part. A touch of raw sienna, wet in wet, suggested algae just above the water line. For the water, I prepared washes in slightly paler versions of the colours of the reflected objects. I applied a pale wash of raw sienna, slightly warmed with light red, to the whole area and began dropping in the prepared washes with vertical brush strokes.

Opposite
Chartwell

Winston Churchill's beloved former home overlooks the Weald of Kent. This view from below the main garden terrace includes the colourful shrubbery that sets off the plain brickwork of the house.

Oast houses

This view is of one of my favourite farms in the Kent countryside. The rich natural tones of the local clay used to make its bricks and tiles harmonise wonderfully with the landscape.

With a scene such as this, it is important to ensure that all the shadows fall in the same direction. Be aware that, if you take a long time to complete your painting, the direction of the shadows may change. To overcome this, sketch them in before you start to paint.

1. Using a 2B pencil, lightly draw in the outline of your composition.

2. With the flat brush and a mix of raw sienna with a touch of light red, put a pale wash over the sunlit clouds, leaving white paper here and there for highlights.

3. Using the No. 10 round brush and a mix of French ultramarine and light red, paint in the cloud shadows, allowing them to blend with the first wash.

4. With the No. 12 brush and a mix of French ultramarine and Winsor blue, green shade, paint in the blue of the sky.

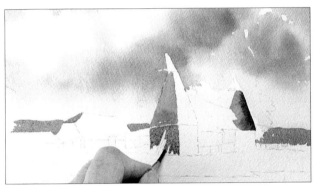

5. Change to the No. 8 brush and using a wash of burnt sienna for the tiles and light red for the brickwork, paint in the oasts. Working wet in wet, add a touch of green to the lower courses.

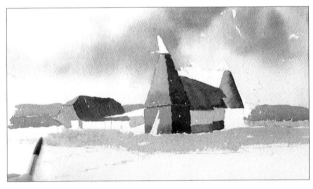

6. Using the No. 10 brush and a flat wash of French ultramarine and light red, paint in the distant hills. Using a mix of raw sienna and Winsor blue and a slightly broken wash, begin to put in the foreground grass.

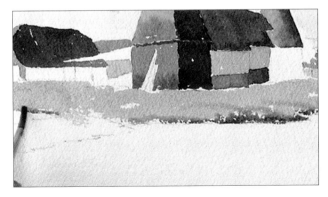

7. Still using the same brush and working wet in wet, add a little burnt sienna and Payne's gray to the lower edge of the grass.

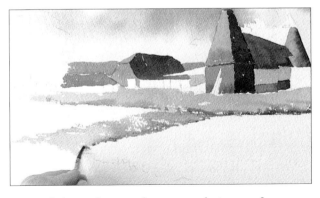

8. Work forward, using the same technique as for step 6, and put in some more grass. Add shadow using the same mix as for step 7.

9. Using the No. 12 brush and a mix of raw sienna and Winsor blue, green shade, put in the trees. Add shadow, wet in wet, using a blend of Payne's gray and burnt sienna.

10. Mix light red and French ultramarine and add a cast shadow to the oast on the right.

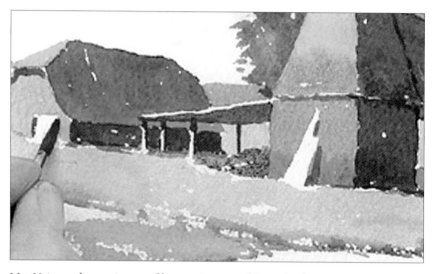

11. Using a deep mixture of burnt sienna and French ultramarine, put in the underside of the lean-to roof, the posts and the shadows on the barn.

12. Using the No. 10 brush and a mix of burnt sienna and Payne's gray, add detail to the oast buildings.

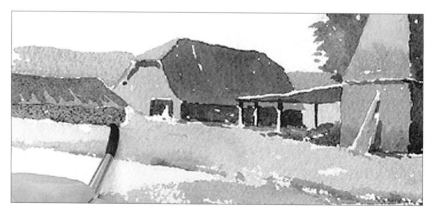

13. Still with the No. 10 brush and a mix of French ultramarine and a touch of light red, apply a wash to the shadowed elevation of the long shed.

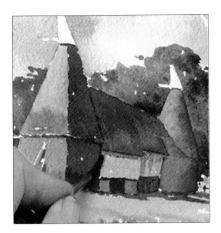

14. Using a mix of light red and French ultramarine, add shadow and texture to the white painted wall.

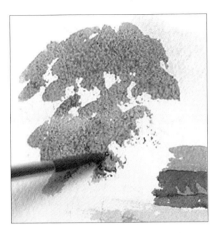

15. Put in the sunlit foliage of the autumnal tree using blends of raw and burnt sienna.

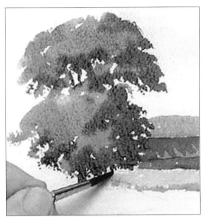

16. Working wet in wet using a mix of light red and French ultramarine, add shadow to the tree.

17. Using the No. 10 brush and a pale wash of raw sienna with a touch of burnt umber, put in the farm track. Allow to dry then, using a mix of burnt sienna and Payne's gray, and following the contours of the ground, begin to put in the tree shadows.

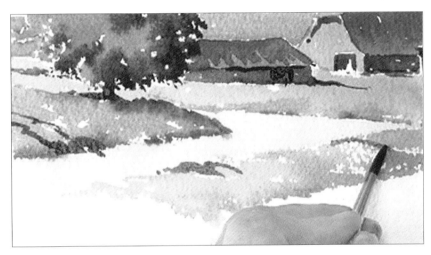

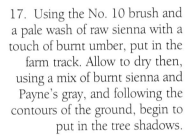

18. With the same mix, continue the tree shadows across the farm track.

19. Change to the flat brush and apply a very pale wash of raw sienna to the water surface.

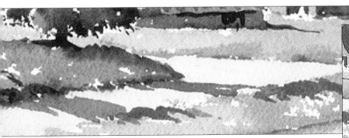

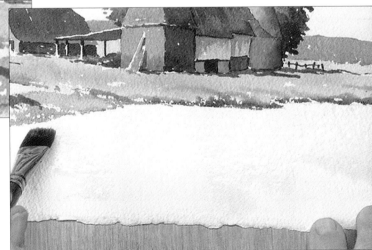

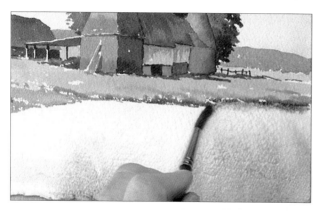

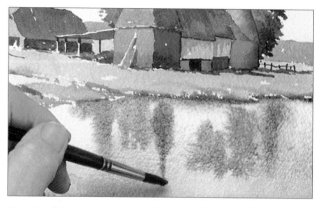

20. Using a mix of French ultramarine and light red, add blue tones to the water. Add shadow beneath the bank with a mix of burnt sienna and Payne's gray.

21. Working wet in wet with vertical strokes, begin to put in the reflections using the colour mixes that were used above.

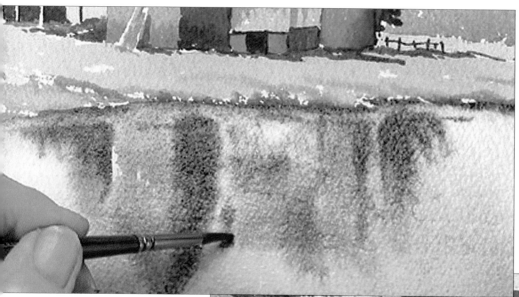

22. While the paper is still moist, add some more vertical strokes in deeper tones for the shadow reflections.

23. With the side of the No. 10 round brush, apply a broken wash of raw sienna to the foreground. Working wet in wet with a mix of burnt sienna and a touch of Payne's gray, add shadow.

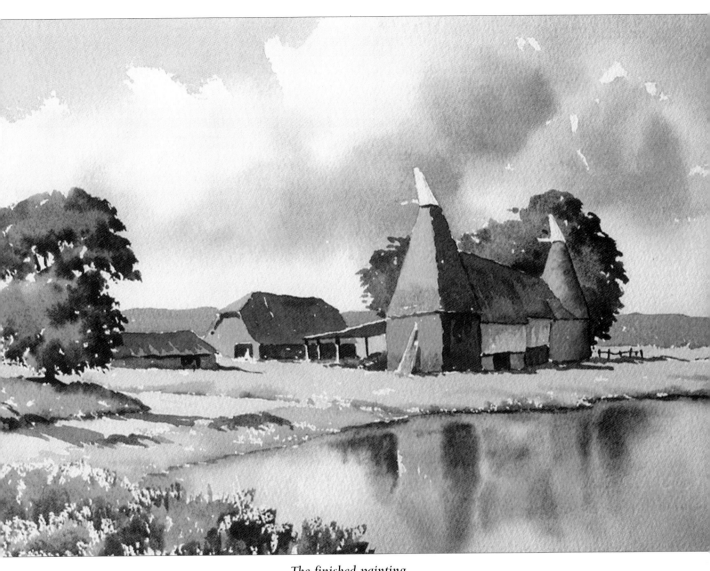

The finished painting

The Fish Market, Venice

This painting is based on a sketch that I made several years ago of the famous fish market in Venice. The buildings are mainly in tones of raw sienna and light red, but it is possible to achieve a remarkable variety of shades and colours by varying the concentration and the amounts of pigment in the washes. When you are adding shadows, pay particular attention to the effect of reflected light.

With a subject such as this, it would be easy to become bogged down in detail. For a more lively and spontaneous result, try to keep your approach free and fairly loose.

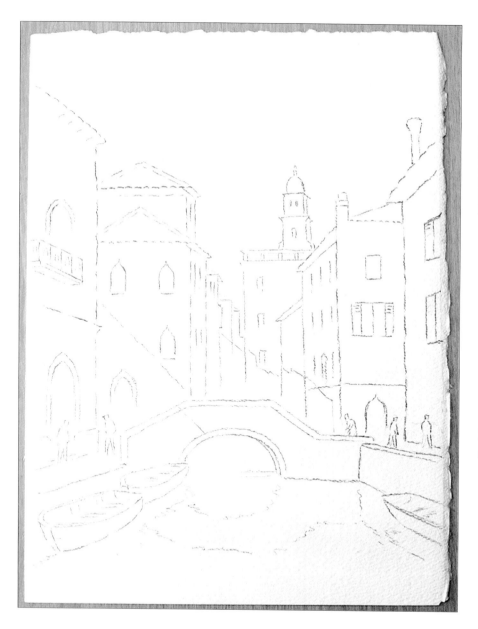

You will need

Rough watercolour paper (see page 8)

2B pencil

Putty eraser

Brushes: 25mm (1in) flat; Nos. 12, 10 and 8 round

Paints: my basic palette (see page 10)

1. Lightly pencil in the outline of your composition.

2. Using the flat brush, apply a pale wash of raw sienna, merging softly into light red towards the horizon.

3. With the No. 10 round brush and mixtures of raw sienna and light red, begin to paint the sunlit elevations of the buildings.

4. Use a pale mix of raw sienna for some of the elevations.

5. Add shadow using the No. 8 round brush and light red and French ultramarine mixes.

6. Paint in the distant tower using the No. 8 brush and a mix of French ultramarine with a little light red,

7. Using light red, paint in the pantiled roofs, leaving white paper 'lines' to suggest form economically.

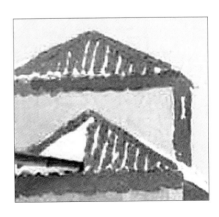

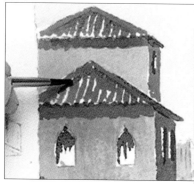

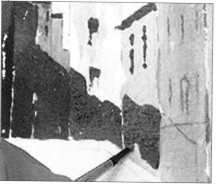

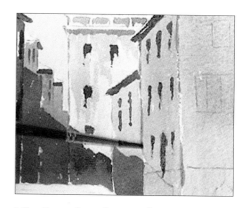

8. Add shadow using a mix of light red and French ultramarine. Use a darker version of the mix for the windows and soffits.

9. Add shadows and windows to the front elevations of the buildings using blends of light red and French ultramarine,

10. Complete the windows using a deep shadow mix of light red and French ultramarine.

12. Using medium and deep shadow mixes, add windows to the side of the building.

11. Add broken, vertical strokes of a light shadow mix to suggest texture on the wall.

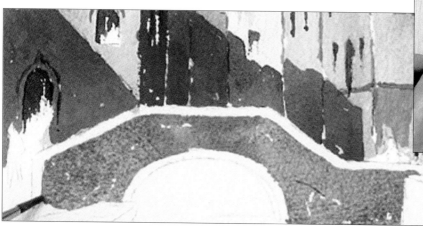

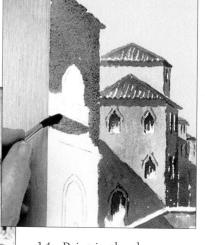

13. Paint in the bridge using mixes of burnt sienna and light red.

14. Paint in the deep tones of the shadowed foreground building using various combinations of French ultramarine and light red,

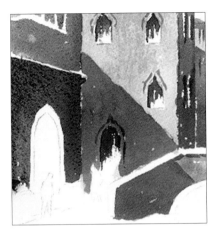

15. Put in some more tones, reserving white paper for detail.

16. Paint in the niches using a dark shadow mix.

17. Strengthen the mix still further and add deeper tones.

18. Using the point of the No. 8 brush, paint in some quick impressions of figures. Change to the No. 10 brush and begin to put in the reflections on the water...

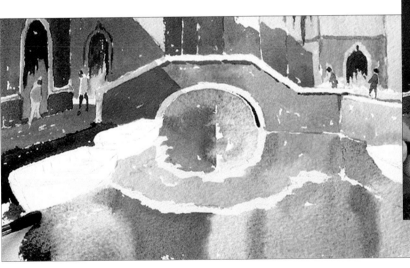

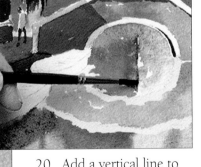

20. Add a vertical line to the reflection to represent the side of the building.

19. ...painting in washes that correspond roughly to the shapes and colours above, and giving them a slightly indented edge to suggest the rippling surface of the water.

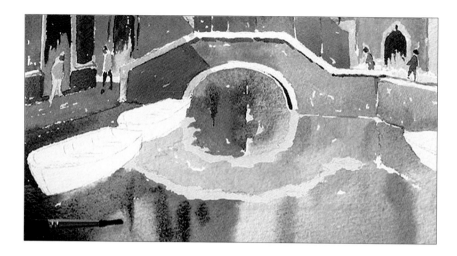

21. Using the No. 8 round brush, begin to add the deeper toned reflections, painting carefully round the shapes of the boats.

22. Add the reflections of the parapet...

23. ...then, using a dark shadow mix, begin to paint in the shadowed sides of the moored boats.

24. Using raw sienna, paint the inside of the boats.

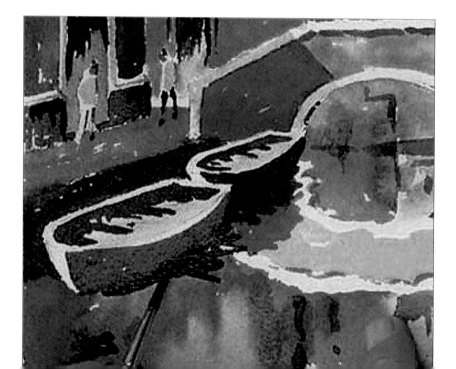

25. Add detail to the boats using a medium shadow mix. Paint in the reflections on the water beneath the boats using a deep mix of French ultramarine and light red.

Opposite
The finished picture

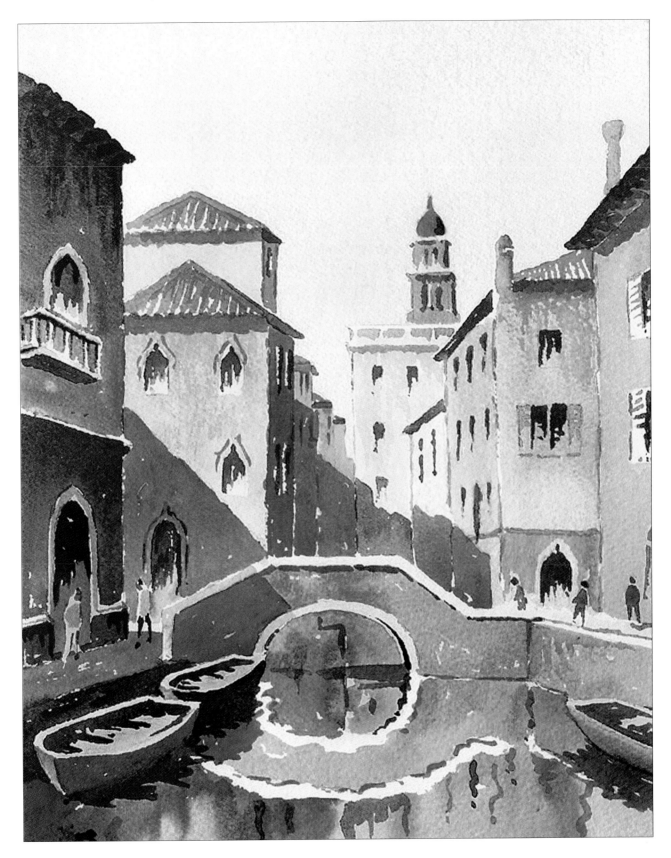

Index

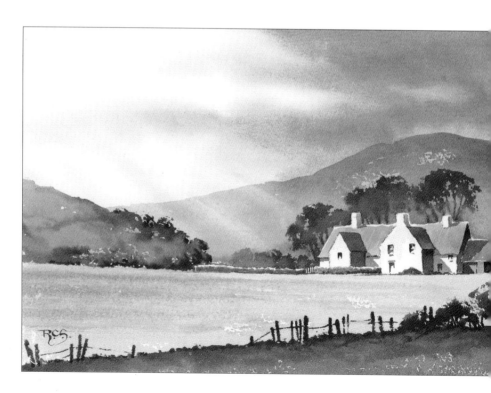